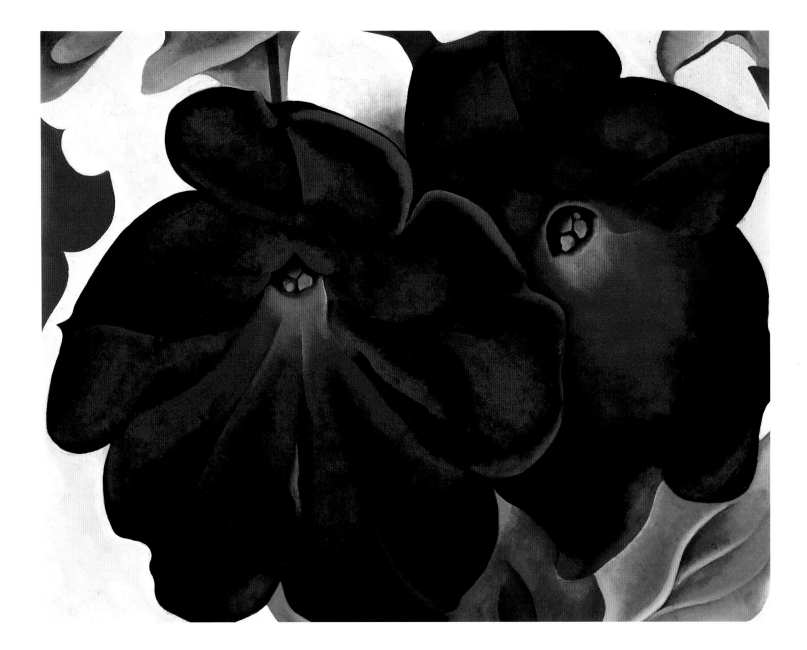

GEORGIA O'KEEFFE

GERALD GP PETERS GALLERY

SANTA FE DALLAS NEW YORK

FRONTISPIECE

Black and Purple Petunias

Oil on canvas
20 by 25 inches
Painted in 1925

REFERENCES: Katherine Hoffman, *An Enduring Spirit:*
The Art of Georgia O'Keeffe (1984), p. 102; Nicholas Callaway,
ed., *Georgia O'Keeffe: One Hundred Flowers* (1987),
illustrated, pl. 30
EX-COLLECTION: The artist; Private collection, Long
Island, New York, since late 1950s

Published on the occasion of the exhibition, "Georgia O'Keeffe":

SANTA FE: November 10 – November 23, 1990
439 Camino del Monte Sol
Santa Fe, New Mexico 87504–0908
(505) 988–8961

NEW YORK: November 28 – December 7, 1990
177 East 78th Street
New York, New York 10021
By appointment (212) 628–9760

DALLAS: December 15, 1990 – January 12, 1991
2913 Fairmount
Dallas, Texas 75201
(214) 969–9023

Catalogue, Copyright © 1990 The Peters Corporation
Library of Congress Catalogue Card Number 90–063231
ISBN: 0–935037–39–X

PREFACE

Much has been said about Georgia O'Keeffe and projected onto her image, her art and her wit. My thoughts in assembling this exhibition come from attempting to make an honest and clear presentation of her work, one that she herself would respect.

It has always been my goal to remember and present Georgia O'Keeffe as an abstract and modern artist. Her work requires discrimination on the part of the viewer to understand the visual language she developed, a language which focused only on the essential. O'Keeffe became accustomed to living and working in wide open spaces and her work, in a similar manner, needs to be viewed in open spaces. There was a crispness to O'Keeffe's vision and a most elegant clarity to her perception that she shared with us, and her work inevitably gives a clearer view to our normally cloudy vision.

I feel it is important when organizing an exhibition of O'Keeffe's work to show sensitivity to who O'Keeffe was as an artist and how she saw her own art. O'Keeffe had a discerning intellect that is not instantly recognizable. It takes time and effort to distinguish what she saw and to see how her visual language evolved over the decades. O'Keeffe's earlier abstract works often give insight to her later works. For this reason, this exhibition presents a broad selection of paintings and works on paper executed over a period of many years.

Georgia O'Keeffe was an artist of great persona about whom many myths have been created which distracted from viewing her art. The majority of her life was focused on creating art and assiduously avoiding conflicts, outside time commitments, associations and places that did not facilitate easy access to her artistic realm. As more time passes and the distractions begin to dissolve, it becomes easier to see her for the master artist that she is.

Gerald P. Peters

1. *Canna Leaves*

Oil on canvas
26 by 11 inches
Painted in 1925

EX-COLLECTION: Estate of the artist

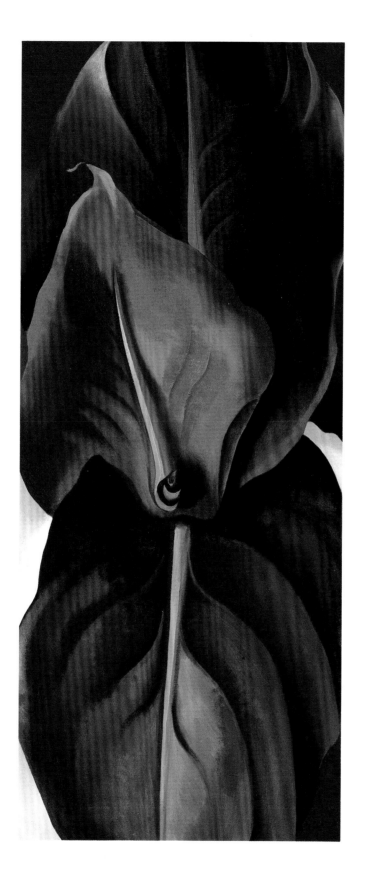

2. *White Calla Lily*

Oil on canvas
32 by 17 inches
Painted in 1927

EX-COLLECTION: Estate of the artist

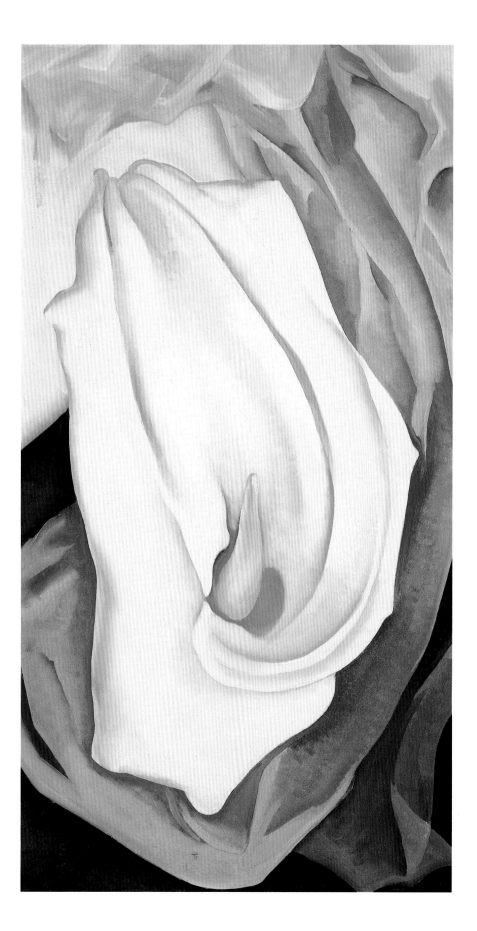

3. *Red Poppy, No. VI*

Oil on canvas
35½ by 29¾ inches
Painted in 1928

REFERENCES: Nicholas Callaway, ed., *Georgia O'Keeffe: One Hundred Flowers* (1987), p. 3, illustrated, pl. 68; Douglas F. Cooley Memorial Art Gallery, Reed College, Portland, Oregon, *Selections From the Reed College Collection* (1989), p. 40, illustrated, pl. 28
EXHIBITIONS: Douglas F. Cooley Memorial Art Gallery, Reed College, Portland, Oregon, "Selections From the Reed College Collection," October–December, 1989
EX-COLLECTION: The artist; [The Downtown Gallery, New York]; Private collection, Seattle, Washington; Reed College, Portland, Oregon

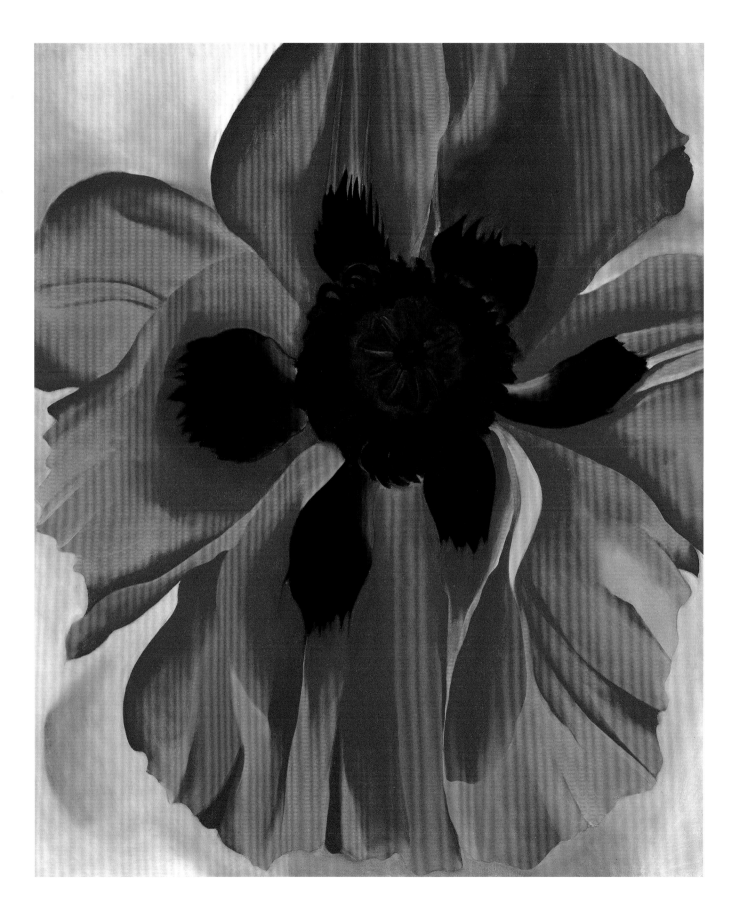

4 · *A White Camelia*

Pastel on paper
21½ by 27½ inches
Executed in 1938

REFERENCE: Nicholas Callaway, ed., *Georgia O'Keeffe: One Hundred Flowers* (1987), illustrated, pl. 93
EXHIBITION: An American Place, New York, "Exhibition of Oils and Pastels," January–March, 1939, no. 19
EX-COLLECTION: The artist; Elizabeth Arden, New York; Estate of Patricia Graham Young

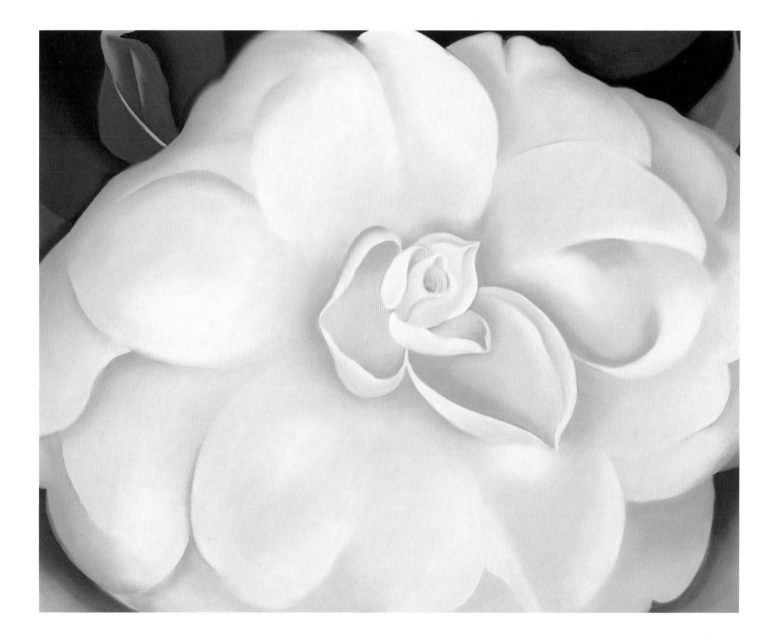

5. *White Calla with Red Background*

Oil on canvas
33½ by 18½ inches
Painted in 1923

EX-COLLECTION: Estate of the artist; [Gerald Peters
Gallery, Santa Fe, New Mexico]; Private collection

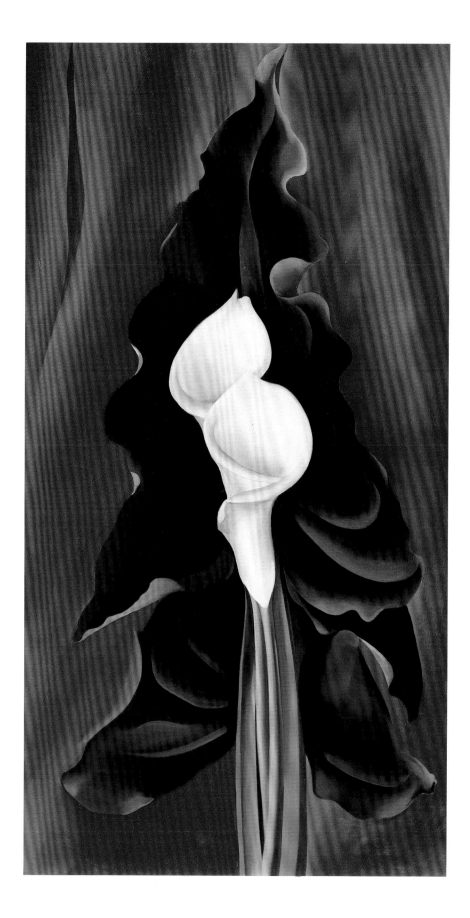

6. *Three Shells*

Oil on canvas
36 by 24 inches
Painted in 1937

REFERENCE: Gerald Peters Gallery, Santa Fe, New Mexico
and The Seibu Museum of Art, Tokyo, Japan, *Georgia
O'Keeffe: Selected Paintings* (1988), p. 62, illustrated, pl. 25
EXHIBITIONS: Phoenix Art Museum, Phoenix, Arizona,
The Seibu Museum of Art, Tokyo and Osaka, Japan, and
Aspen Art Museum, Aspen, Colorado, "Georgia O'Keeffe:
Selected Paintings," April 15, 1988 – February 12, 1989
EX-COLLECTION: The artist; Private collection; [Gerald
Peters Gallery, Santa Fe, New Mexico]; Private collection,
New York; Steve Koman, Winchester, Virginia

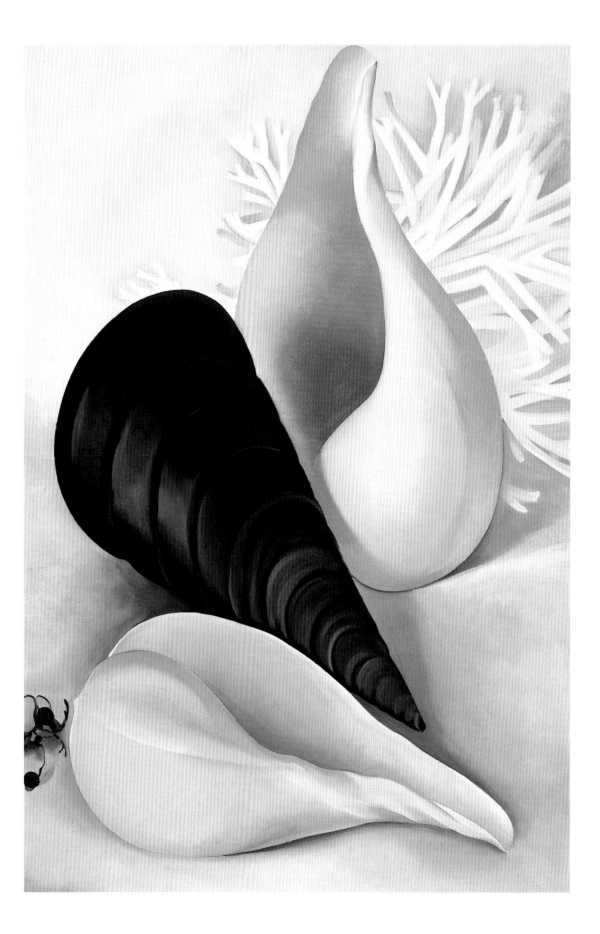

7. *Abstraction, Red and Black Night*

Oil on board
12⅝ by 9⅞ inches
Painted in 1929

EXHIBITION: The Fine Arts Museums of San Francisco,
San Francisco, California, "Charles Demuth: From the
Garden to the Chateau," March 7 – June 10, 1990
EX-COLLECTION: [The Downtown Gallery, New York];
Private collection

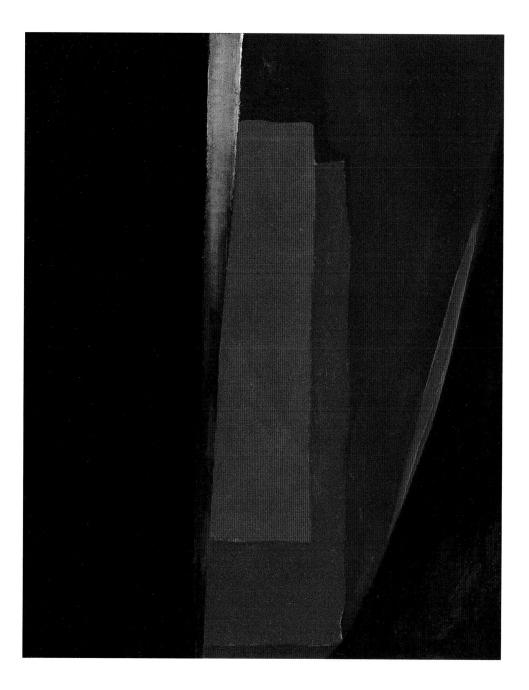

8. *Little House With Flagpole*

Oil on canvas
35½ by 17½ inches
Painted in 1925

EXHIBITION: McNay Art Institute, San Antonio, Texas,
"Georgia O'Keeffe," October 24 – November 30, 1975, no. 25
EX-COLLECTION: The artist; Private collection,
San Antonio, Texas

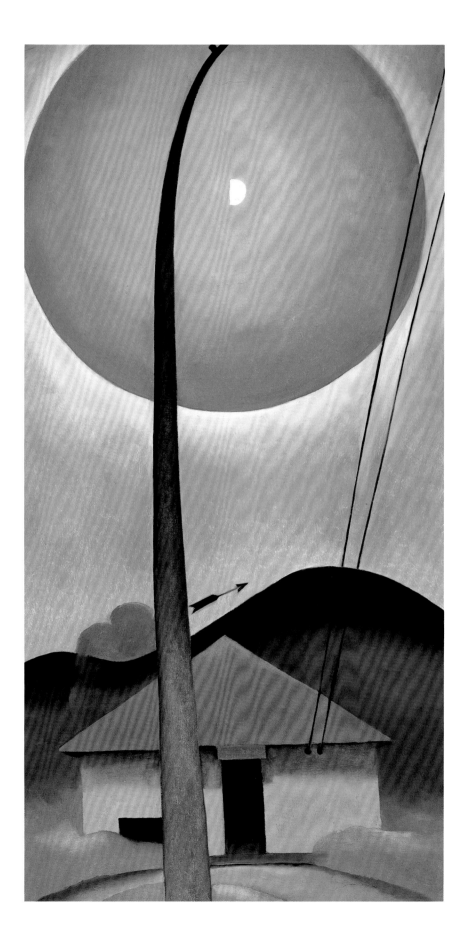

9. *Maple & Cedar (Red)*

Oil on canvas
25 by 20 inches
Painted in 1923

EX-COLLECTION: Estate of the artist

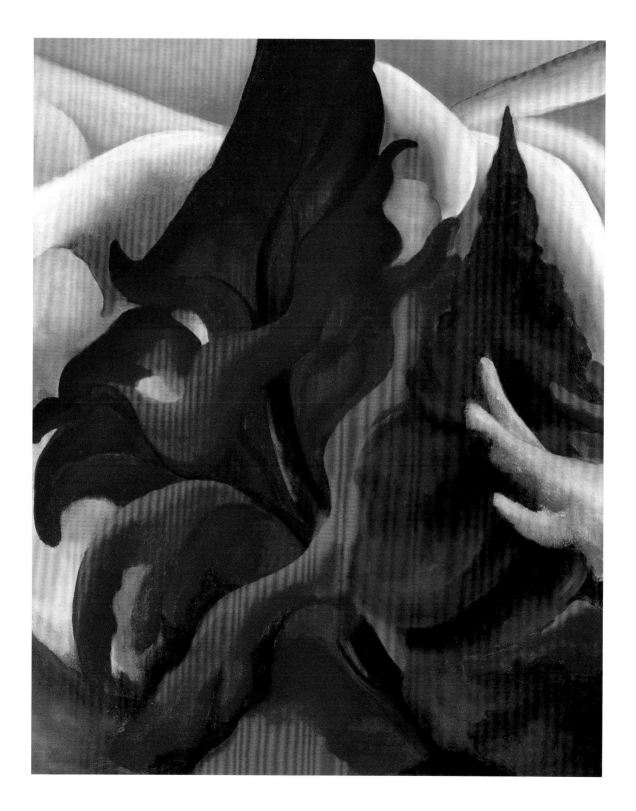

10. *Spring Tree No. II*

Oil on canvas
30 by 36 inches
Painted in 1945

REFERENCES: The Amon Carter Museum, *Paintings by Georgia O'Keeffe* (1966), p. 29; Lloyd Goodrich and Doris Bry, *Georgia O'Keeffe* (1970), no. 98, illustrated
EXHIBITIONS: An American Place, New York, "Georgia O'Keeffe," February–March, 1946, no. 2; The Museum of Modern Art, New York, "Georgia O'Keeffe Retrospective Exhibition," May–August, 1946, no. 51; The Amon Carter Museum, Fort Worth, Texas and The Museum of Fine Arts, Houston, Texas, "Paintings by Georgia O'Keeffe," March–July, 1966; The Whitney Museum of American Art, New York, The Art Institute of Chicago, Chicago, Illinois and The Fine Arts Museums of San Francisco, San Francisco, California, "Georgia O'Keeffe Retrospective Exhibition," October, 1970–April, 1971
EX-COLLECTION: The artist; Estate of Anita O'Keeffe Young

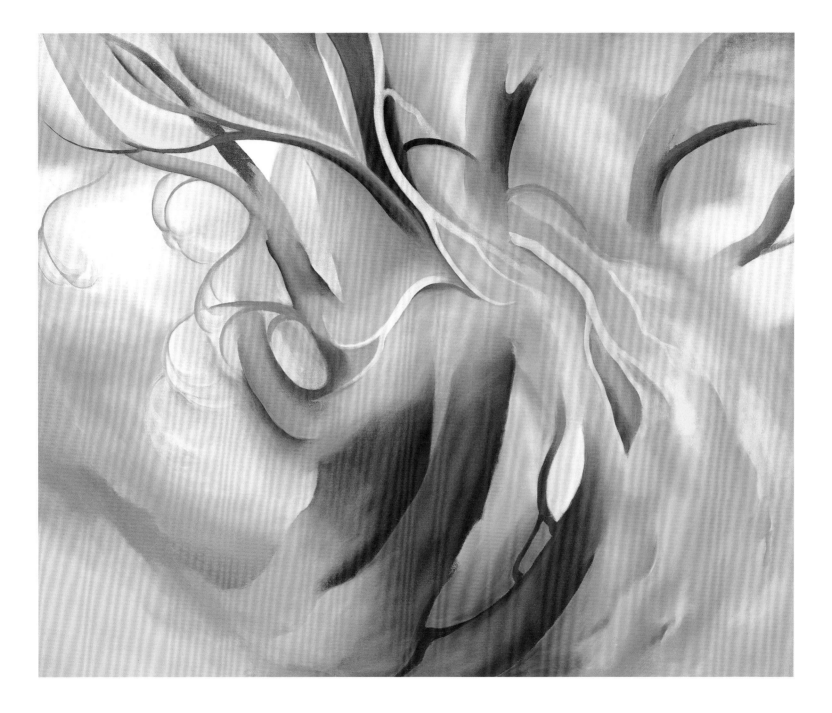

11. *Cottonwood No. 1*

Oil on canvas
30 by 36 inches
Painted in 1944

REFERENCE: Gerald Peters Gallery, Santa Fe, New Mexico
and The Seibu Museum of Art, Tokyo, Japan, *Georgia
O'Keeffe: Selected Paintings* (1988), p. 74, illustrated, pl. 31
EXHIBITIONS: Phoenix Art Museum, Phoenix, Arizona,
The Seibu Museum of Art, Tokyo and Osaka, Japan, and
Aspen Art Museum, Aspen, Colorado, "Georgia O'Keeffe:
Selected Paintings," April 15, 1988–February 12, 1989
EX-COLLECTION: Estate of the artist

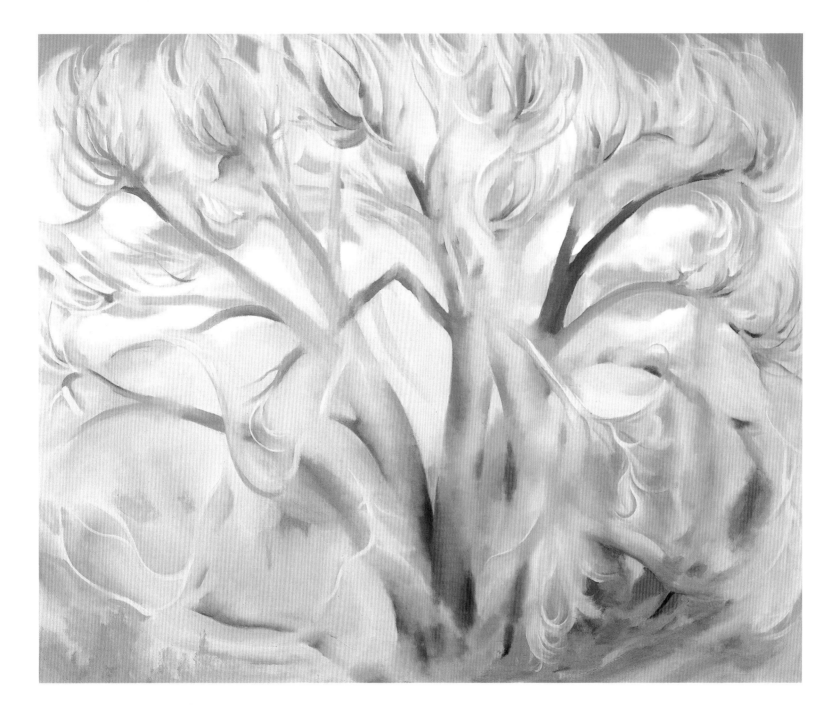

12. *Winter Cottonwoods East V*

Oil on canvas
40 by 30 inches
Painted in 1954

REFERENCES: The Amon Carter Museum, *Paintings By Georgia O'Keeffe* (1966), p. 26, illustrated; Lloyd Goodrich and Doris Bry, *Georgia O'Keeffe* (1970), no. 106, illustrated
EXHIBITIONS: The Downtown Gallery, New York, "O'Keeffe Exhibition of New Paintings," March–April, 1955, no. 12; Worcester Art Museum, Worcester, Massachusetts, "An Exhibition by Georgia O'Keeffe," October–December, 1960, no. 34; The Amon Carter Museum, Fort Worth, Texas and The Museum of Fine Arts, Houston, Texas, "Paintings by Georgia O'Keeffe," March–July, 1966; The Whitney Museum of American Art, New York, The Art Institute of Chicago, Chicago, Illinois and The Fine Arts Museums of San Francisco, San Francisco, California, "Georgia O'Keeffe Retrospective Exhibition," October, 1970–April, 1971
EX-COLLECTION: The artist; Estate of Anita O'Keeffe Young

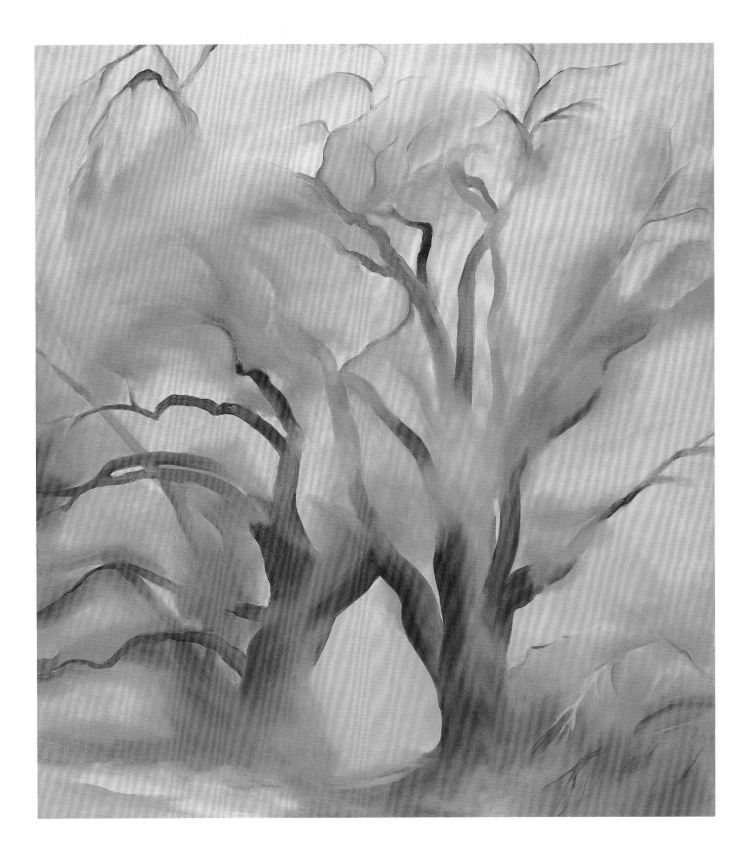

13. *Part of the Cliffs*

Oil on canvas
20 by 32 inches
Painted in 1937

EX-COLLECTION: Estate of the artist; [Gerald Peters
Gallery, Santa Fe, New Mexico]; Private collection,
Fort Worth, Texas

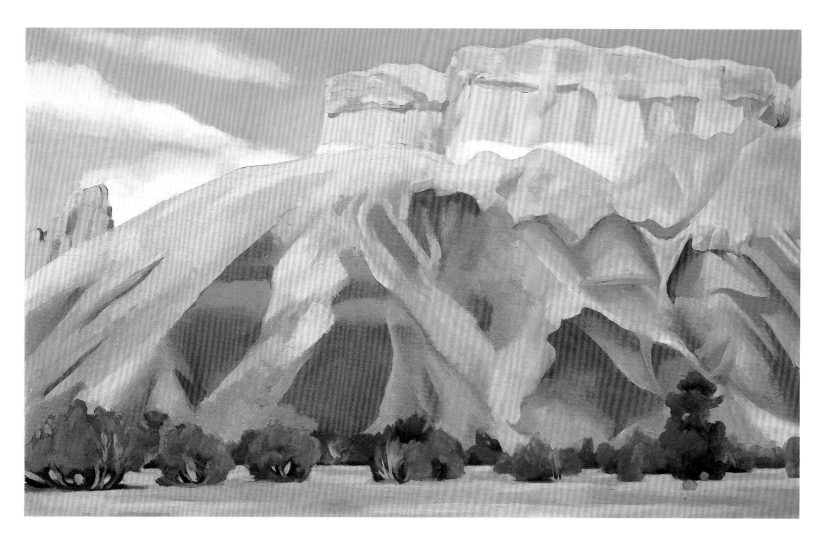

14. *Mule's Skull With Turkey Feathers*

Oil on canvas
30 by 16 inches
Painted in 1936

REFERENCES: The Amon Carter Museum, *Paintings by Georgia O'Keeffe* (1966), p. 29; Gerald Peters Gallery, Santa Fe, New Mexico and The Seibu Museum of Art, Tokyo, Japan, *Georgia O'Keeffe: Selected Paintings* (1988), p. 58, illustrated, pl. 23

EXHIBITIONS: An American Place, New York; The Downtown Gallery, New York; Cleveland Museum of Art, Cleveland, Ohio, "American Painting from 1860 until Today," June 22–October 4, 1937; The Art Institute of Chicago, "Georgia O'Keeffe," January–February, 1943; The Amon Carter Museum, Fort Worth, Texas, and The Museum of Fine Arts, Houston, Texas, "Paintings by Georgia O'Keeffe," March–July, 1966; Phoenix Art Museum, Phoenix, Arizona, The Seibu Museum of Art, Tokyo and Osaka, Japan, and Aspen Art Museum, Aspen, Colorado, "Georgia O'Keeffe: Selected Paintings," April 15, 1988–February 12, 1989

EX-COLLECTION: The artist; Private collection, Santa Fe, New Mexico; by descent through the family; [Gerald Peters Gallery, Santa Fe, New Mexico]; Private collection, Dallas, Texas

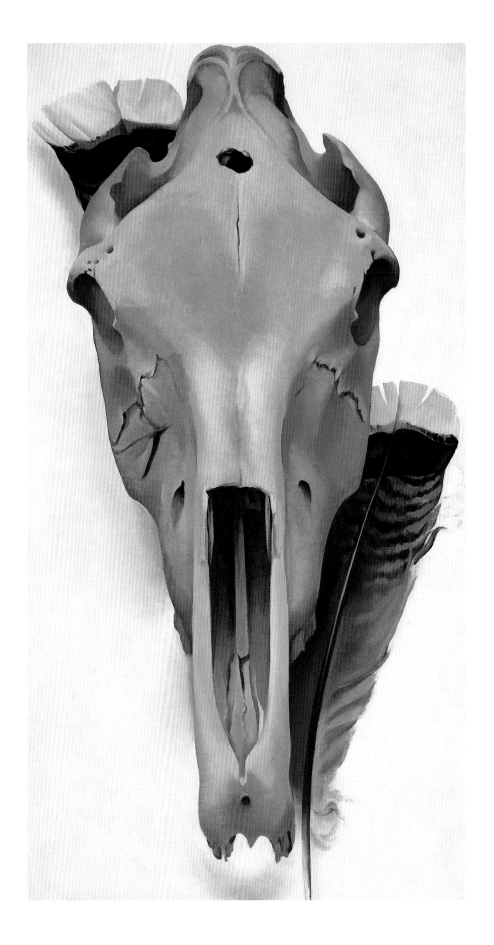

15. *Two Austrian Copper Roses IV*

Oil on canvas
24 by 20 inches
Painted in 1957

EX-COLLECTION: The artist; [The Downtown Gallery, New York]; Doris Bry, New York; Mr. and Mrs. Leigh Block; [John Berggruen Gallery, San Francisco, California]; [Gerald Peters Gallery, Santa Fe, New Mexico]; Private collection

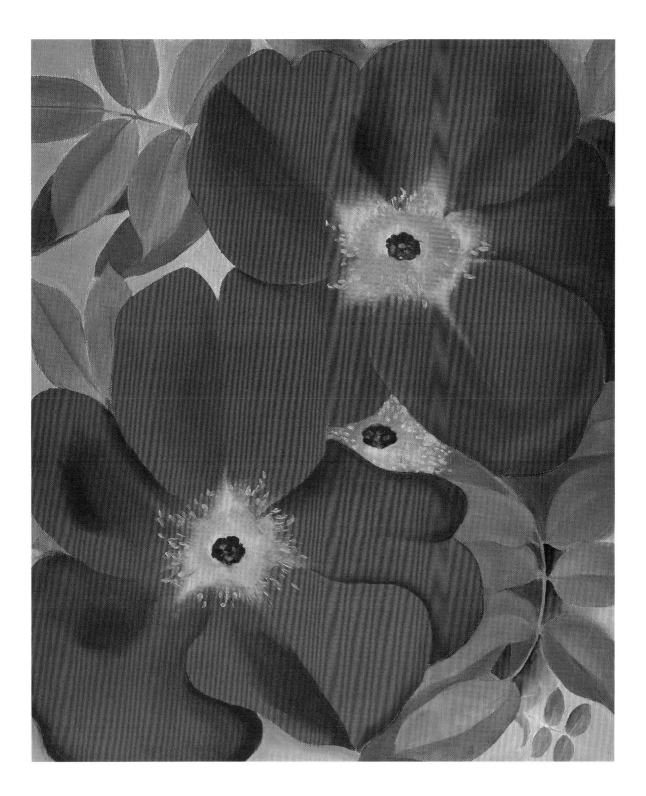

16. *Lily*

Pencil on paper
10½ by 15 inches
Executed in 1930

EX-COLLECTION: The artist; Private collection, New York

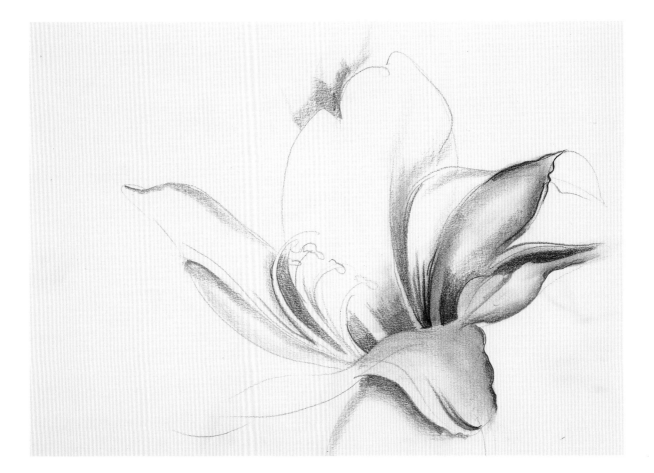

17. *Kachina*

Watercolor
21¼ by 14¼ inches

EX-COLLECTION: The artist; Private collection,
New Mexico

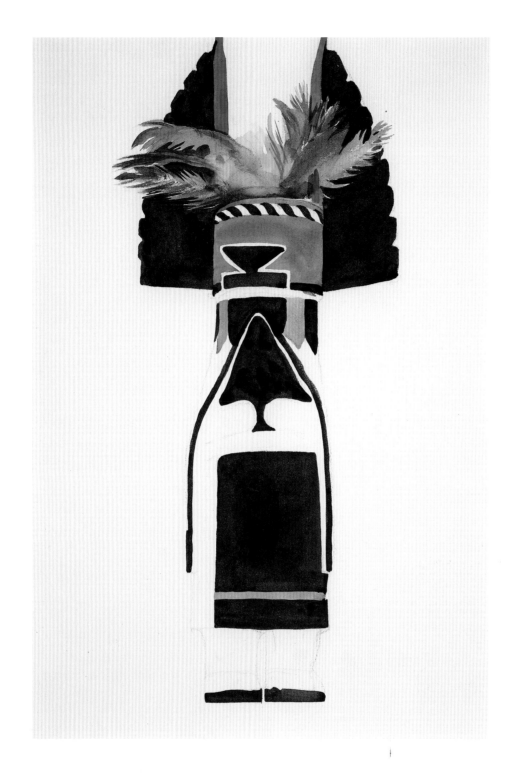

18. *Blue Headed Indian Doll*

Watercolor
20½ by 11½ inches
Executed in 1935

EX-COLLECTION: The artist; [Gerald Peters Gallery, Santa
Fe, New Mexico, 1984]; Private collection, Dallas, Texas

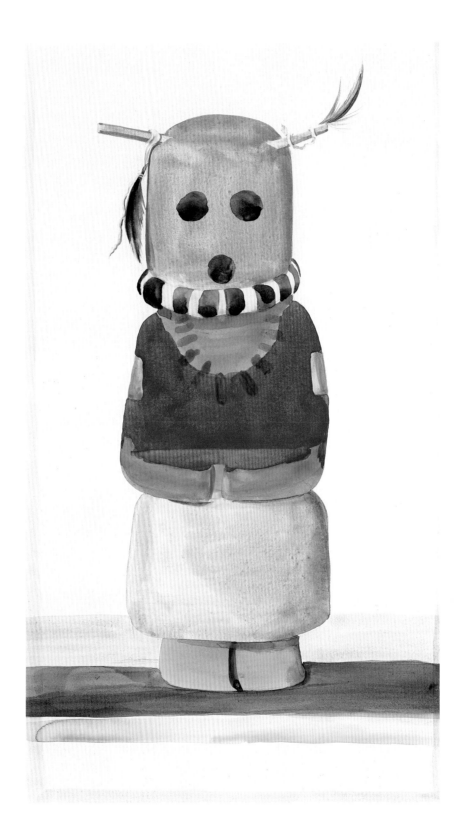

19. *Abstraction, Pale Sun*

Watercolor
17 by 12½ inches
Executed in 1917

EX-COLLECTION: The artist; Private collection, New York

20. *Red and Black*

Watercolor
12 by 9 inches
Executed in 1916

REFERENCES: Constance Shwartz, *Nevelson and O'Keeffe: Independents of The Twentieth Century* (1983), p. 28, illustrated, no. 23; Gerald Peters Gallery, *Georgia O'Keeffe: Selected Paintings and Works on Paper* (1986), illustrated, pl. 33
EXHIBITIONS: Nassau County Museum of Fine Art, Roslyn Harbor, New York, "Nevelson and O'Keeffe: Independents of the Twentieth Century," 1983; Washburn Gallery, New York, "Americans: The Early Decades," 1985; Gerald Peters Gallery, Dallas, Texas, "Georgia O'Keeffe: Selected Paintings and Works on Paper," June 14–July 14, 1986

21. *Apple*

Pastel on paper
8¾ by 7¼ inches
Executed c. 1920–1921

EXHIBITIONS: Anderson Galleries, New York, "Stieglitz
Presents 100 Pictures, Oils, Watercolors, Pastels, Drawings
by O'Keeffe," January–February, 1923
EX-COLLECTION: Georgia Engelhardt Cromwell (Alfred
Stieglitz's niece) until 1955; Private collection

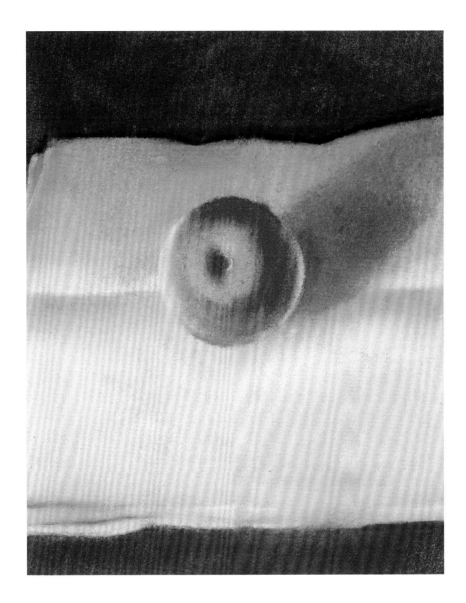

Exhibition and catalogue coordinated by Katie Flanagan
Photography coordinated by Dan Morse
Catalogue design by Eleanor Caponigro
Typesetting, printing and binding by Meriden-Stinehour Press